JUSTICE IS OUR LOVE IN ACTION

Poetry
by
Stewart Acuff
Art
by
Mitch Klein

Published by Hard Ball Press.

ISBN: 978-1-7328088-0-5

Cover Art: Mitch Klein

Exterior and interior book design by T. Sheard & D. Bass.

Information available at: www.hardballpress.com

What would it mean?

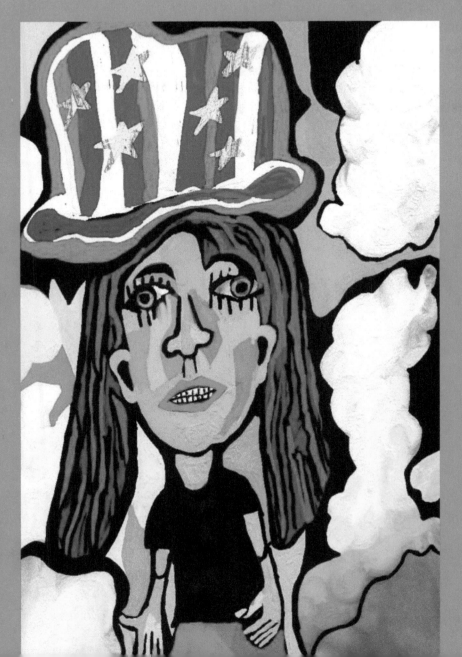

While we rage against evil
And mourn out loud the destruction of democracy
We must ever remember that our efforts are
born of the struggles in our own souls
That all that is good ultimately comes from
Love.
We re-commit ourselves to an ever expanding definition of justice
Justice is our Love in action
Let us live to see the Other as brother or sister

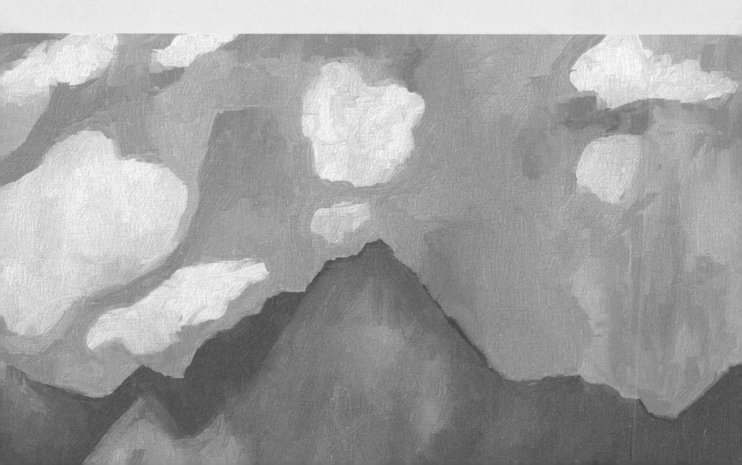

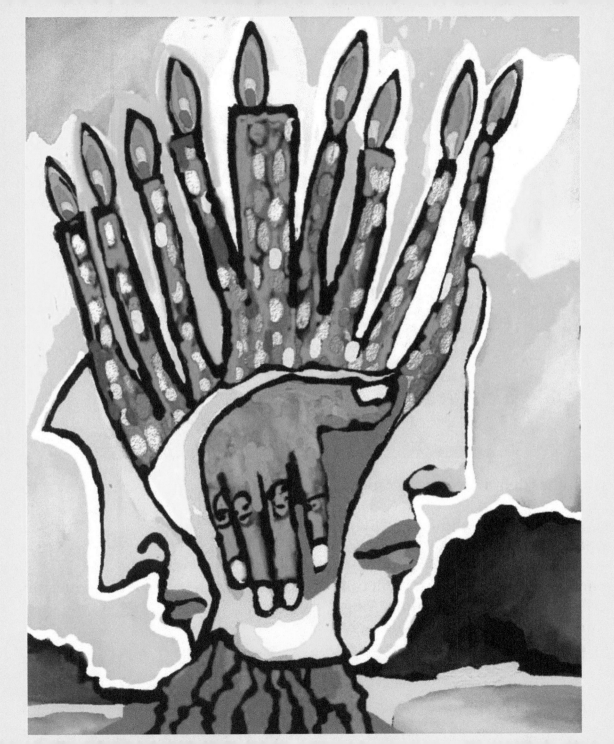

Just another debt I owe you for focusing on the hopeful.

That voice is It, The Light, The Divine inside you.
Or maybe the Universal.

We are blessed in this work I will call RIGHTEOUS in the old southern meaning
--walking boldly in The Light, strong
because you know you're doing right,
proclaiming justice, demanding freedom.

In memory of Jon Kest.

What would it mean for all of us

For the most powerful country in the world to destroy its own democracy

We suffer here the daily dismissal of democratic understandings

We watch with fear the daily disparaging of our eternal Constitution

We lie awake and worry about how our progeny make a living

But if as I believe we are all children of God,

what does it mean for all our world

When all the wealth and weaponry ever imagined

Is turned to taking the world's wealth for only those at the top

What would it mean in a poor ravaged country like

Sierra Leone where my life was barely spared

For the hope America created in democracy and

human rights to be spent in destruction of what makes us human

I see the diseases of despair all around me

Scars from needles and heroin, meth teeth, addiction, alcoholism

Young people too willing to give up, to die in life,

to accept death or prison

The dead eyes of the panhandlers playing a role for another bag of

heroin or rock of crack

The young folks and old men waiting for a liquor store to open

It is what happens when you rip away any way to make a living

Souls will die, hearts will shatter

But now that living death spreads

It spreads to those making a living but watching democracy die

Living death spreads to mothers and fathers

grieving good opportunities gone

Those too old and tired and hurt to work but too poor not to

Living death haunts us all now.

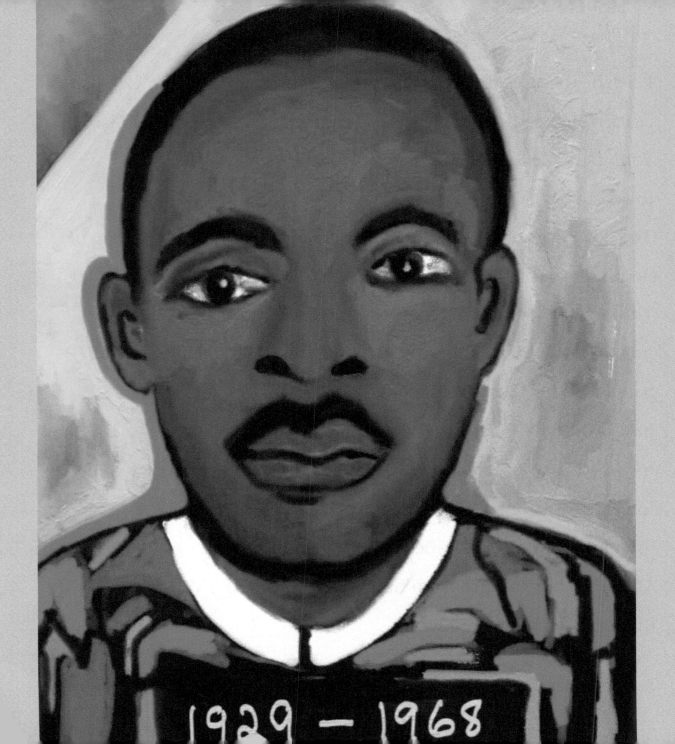
1929 — 1968

We learn again in America

The sometimes awful cost of freedom

All who desire liberation must pay a personal price

Some will lose the source of income

Many will sacrifice relationships

The personal price of our freedom cannot be paid in some faraway place

The cost cannot be bought by some other one

In this resistance we are paying a collective price

The collective cost does pay the personal price

Dr. King and Cesar paid their personal price with their lives--AND--

They put down the first payment of our cost

So we struggle to find strength in each other, and

To nourish the souls of one another

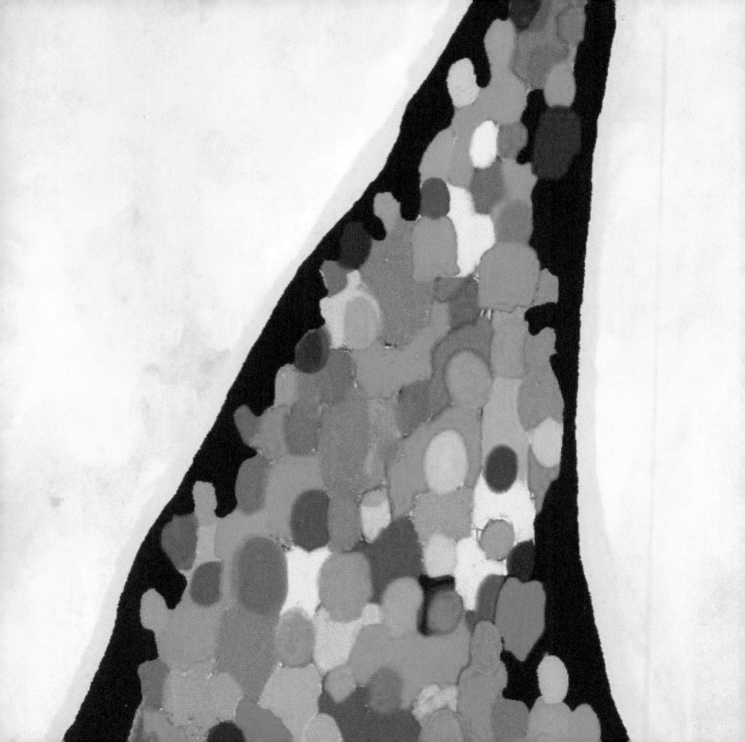

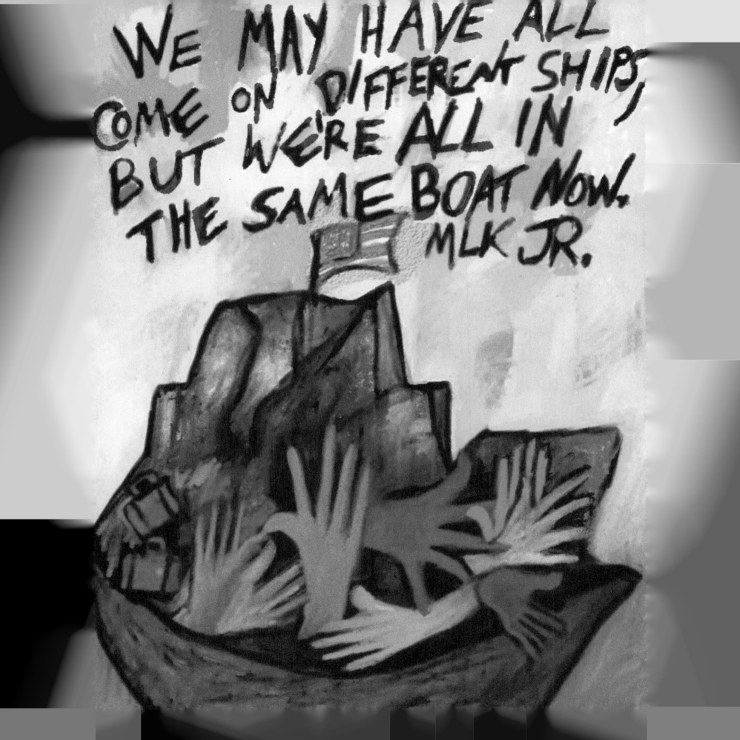

I sometimes wonder what it is that Dr. King missed

Could he still feel the South Alabama breeze on his cheek

Or was his mind too consumed with worry

On the March from Selma to Montgomery

Did the red velvet cake still taste as great on tables of church ladies

In Bombingham when Bull Connor was turning loose dogs on kids

Or was his heart too dark with fear for their lives

Not his own, there's no indication he ever feared death

Not even in Memphis when he marched with the sanitation men on

strike for justice

In Memphis did Dr. King take a break to watch the Mississippi River roll by

Or was his soul open to any beauty on the day,

April 3 he peeped his own death

What did Dr. King miss that blesses me every day.

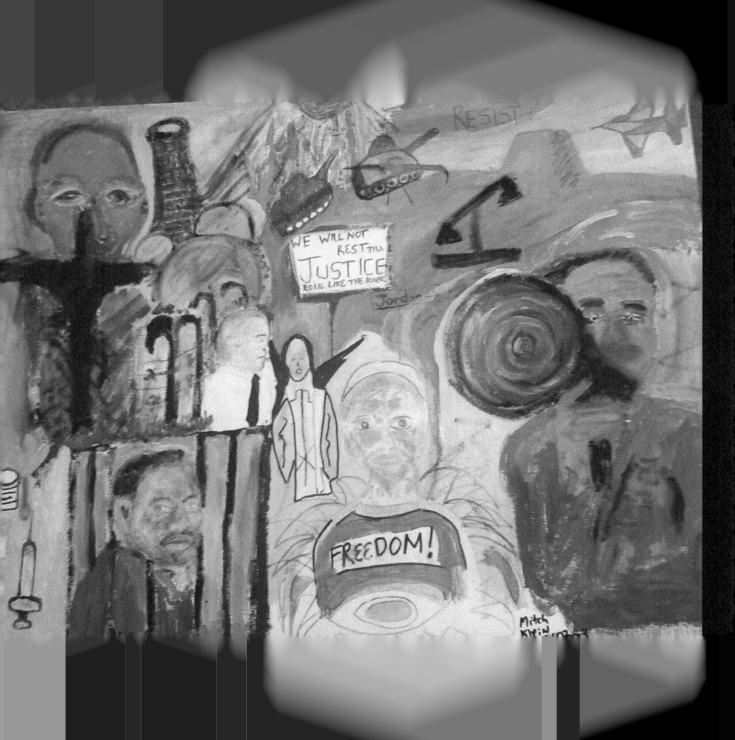

Dr. King taught us the kind of Love that will overcome

Ain't a patient love, it ain't a waitin love nor a lazy love nor a caint kind of love

It's a marchin love and votin and registerin and doorknockin and phonin and postin and rallyin and hell raisin love and jail goin love and sittin in and walkin picket lines love

It's love in action, what some folks call justice.

It's millions and millions movin for ourselves and our families and for other families and for The Other

It's holy solidarity love, bound by common humanity love

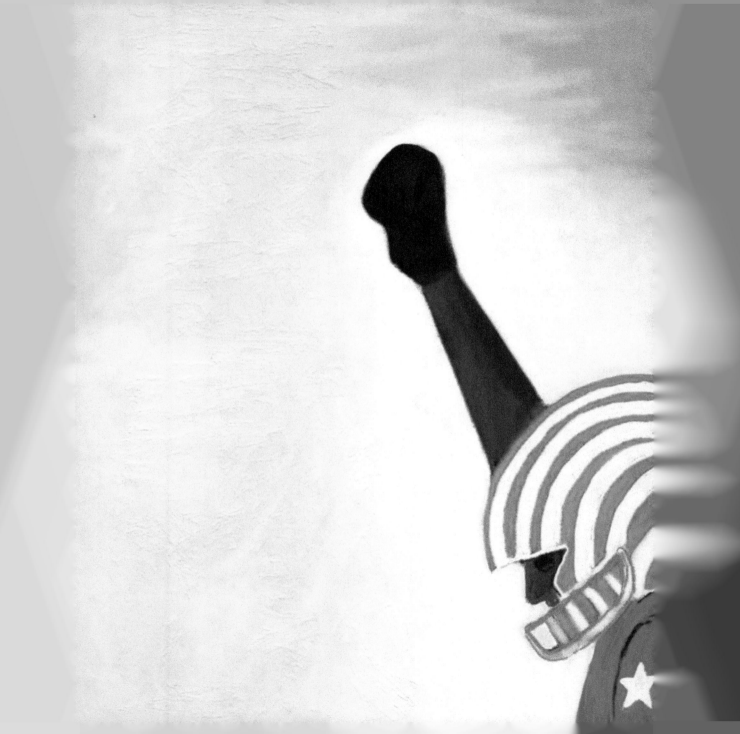

Fog sits silent in this Sunday night

Colors muted by moisture in thickened air

The lines and corners of buildings rising become less distinct

Like memories of life lived hard softened by grace and mysteries beyond humanity

Demons finally quieted at least for now

Alone in serenity and peace but not without wanting

A man is blood and bone as well as soul and heart

An empty evening invites a past long gone back to play

So I feel the pull of a big bluegill in a pond that waters cattle and sundown on a lake in the Ozarks and early morning on that same lake, water glass smooth and the dock where I worked and sleeping on trains running through Europe And picket lines at midnight praying for peace but ready for whatever could come out of the darkness behind the blinding lights of truck crowded with boys wanting to be klansmen and jails all across Georgia where men wait in concrete cages for anyone to go their bail and sweat soaked days knocking on doors of workers wanting a better life, breathing teargas through a wet bandana in the streets of Seattle and DC and Miami

You lived hard and fast as you could so you could stop on a quiet night when the fog hangs heavy.

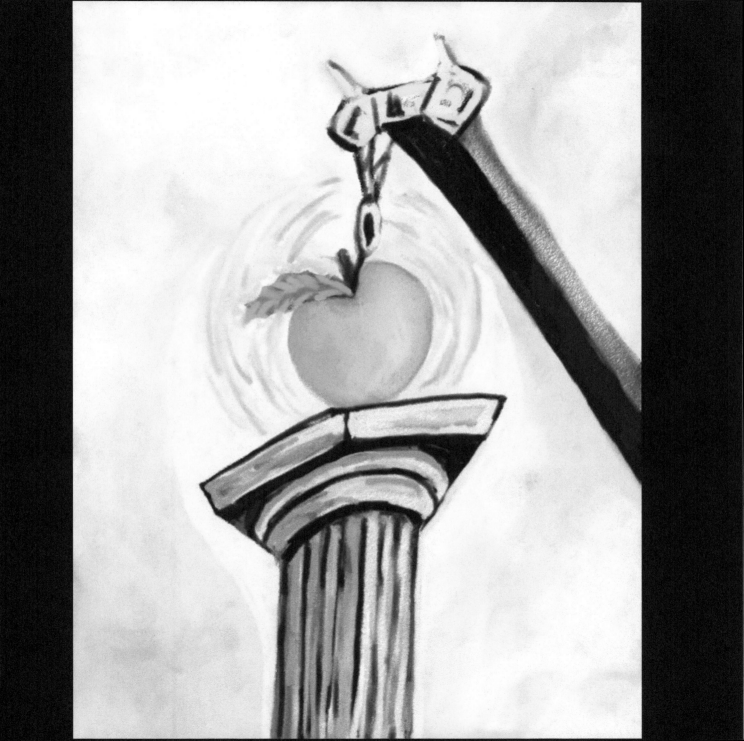

SUNSHINE

We drove just one town west of where we are now

Stunningly bright sun shine

Cotton boll clouds float in Caribbean blue sea of sky

We talked while the wheels whined on the highway

I wondered how one mortal man would sacrifice this scene

For illgotten gains and wealth wasted on those who already have too much

Following the river at the foot of these mountains

I mourn my memory of the natural South I once knew

The rural South my kids can never know

My heart shrinks in a righteous rage

It is not his to sacrifice

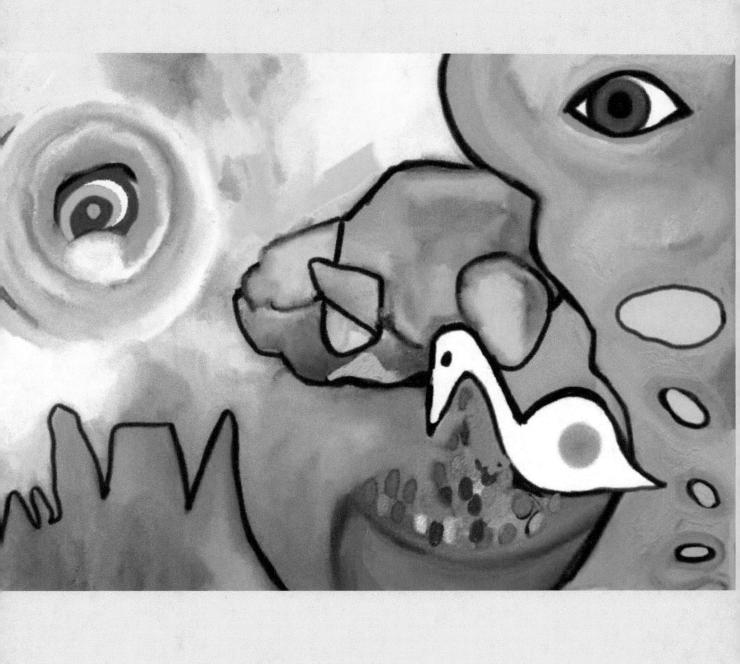

When you face the abyss

Balanced on uneven ground

When light battles dark

And hope struggles against despair

When your compassion is outweighed

By the twins of anger and hatred

When your breath comes shallow with dread

It is love that sustains

And maybe only love

Love one another

Resistance will come

When we refill the souls of each other

Back in the bottomlands where I was born and really raised

The land leading down to the rivers was so low it flooded every spring

And in the flooded woodlands flourished stunning cypress trees

When they grew in water, they grew knees that poked up above the water

The knees breathed for the trees

They made wonderful lumber, beautiful and fire resistant

And so grandpa's acumen and oxen paid for the farm

That Mom was born and bred on

So that mud from those bottomlands is mixed in my blood

Proud of all that mud and blood and roots

I still love much of the way we lived

Huntin n fishin in the wild trackless bottoms where most didn't go

I loved to fish for bream and bass and catfish

Then cleanin a mess for Momma to fry with hushpuppies.

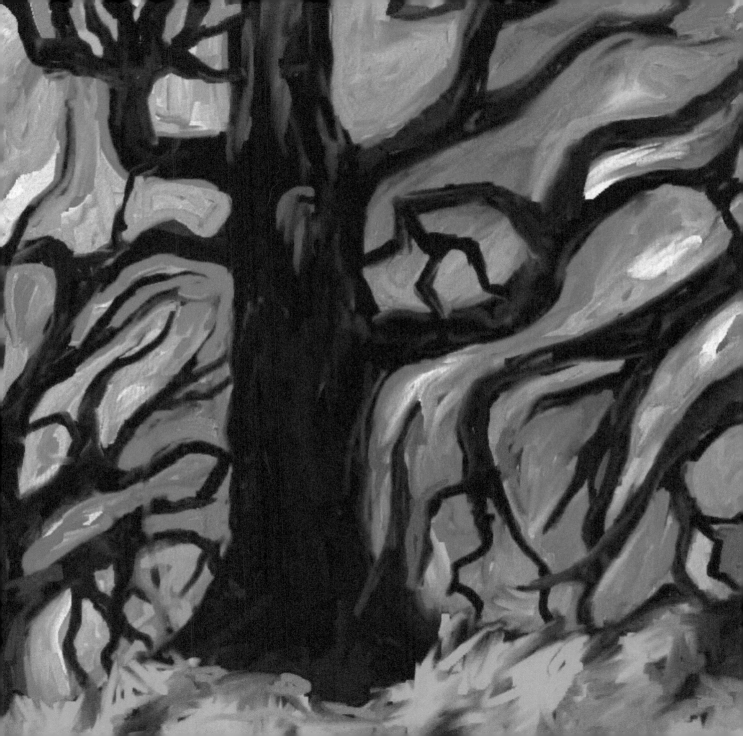

Watching the twin rivers which flow through this verdant valley

I learn about how water moves and the power it gathers as it goes

Now in early summer, spring rains still coming, the rivers rise, unstop-

pable rolling over every obstacle

Later this summer the rivers will recede, slowing into a mellow flow, still

unstoppable and powerful but peaceful

I grew up along the massive and sometimes mysterious Mississippi River

When I worked in Memphis I spent many evenings with a quart of malt

liquor watching the Mississippi make its unending way to New Orleans

I watched the swirl of its currents, the eddys and the power of its push to the sea

All while the surface is still serene

That is how I want to be

Flowing over or through or above any obstacle

Power without force, strength without strain

Flowing, never stopping to the sea the divine has for me

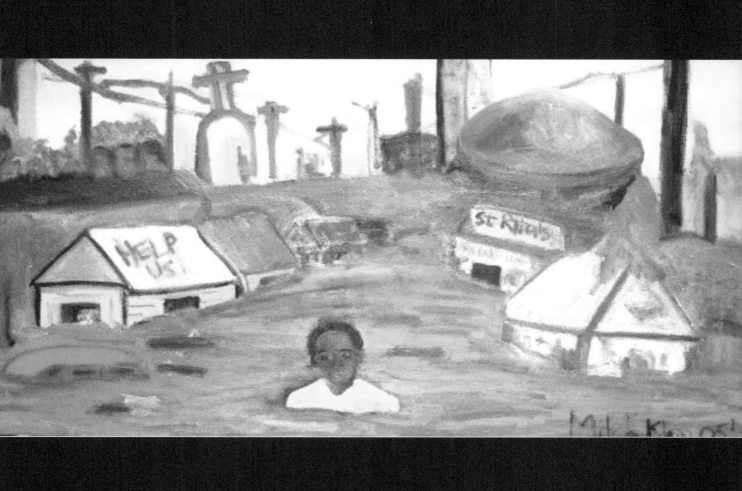

Choking Dust

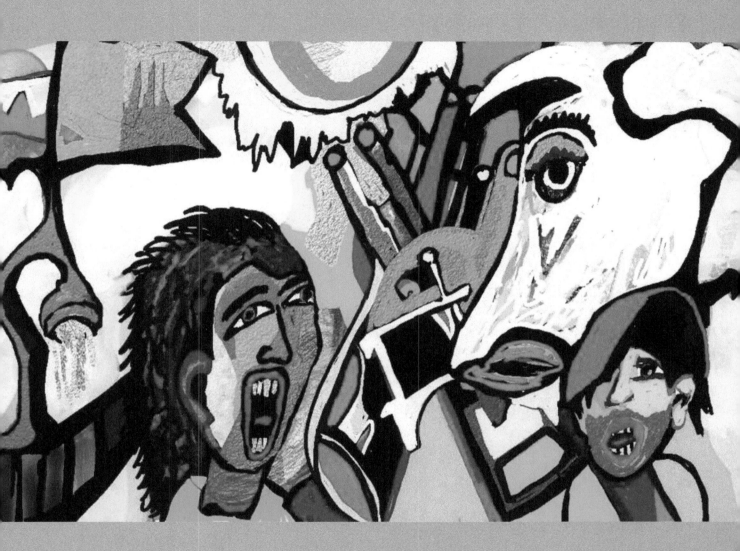

When we and our leaders refuse to honor

The humanity of our own people

Embracing the empty bigotry of our history

And sacrifice souls of sisters and brothers

On the demons' despicable deathly altar of a poisonous putrid power

We deprive our own selves of pieces of our souls

And neuter our nation's own claim to justice

When we seek to send our young away

To a place and a fate no one knows

To claim a false and flimsy front of manhood

As we rely on and celebrate ghastly ghosts of fascism

We as a country make a mockery of the best of our history

The very cause of America, the reason for America crumbles to a choking dust

To sacrifice lives for a hastening hate

Eating away at the USA

We mourn the lost noble nature of our nation.

And we weep the tears of a people lost.

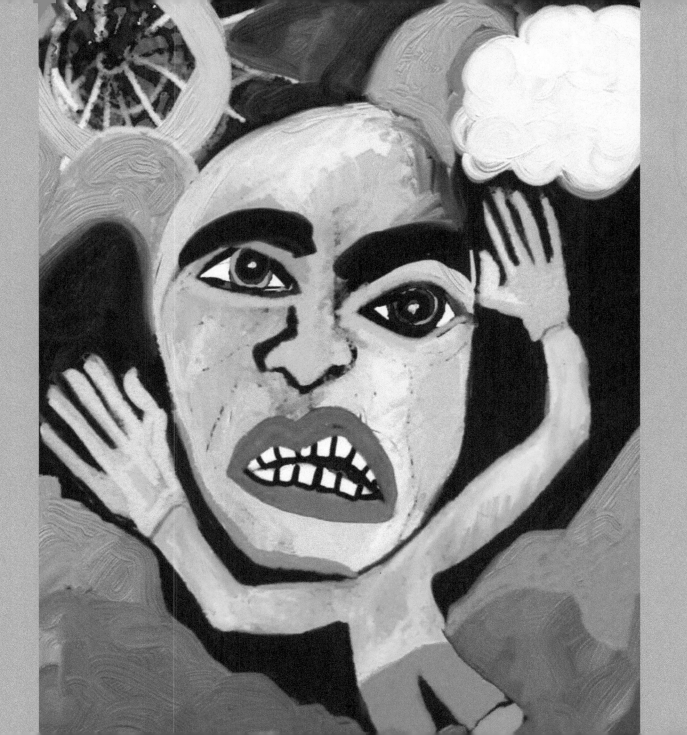

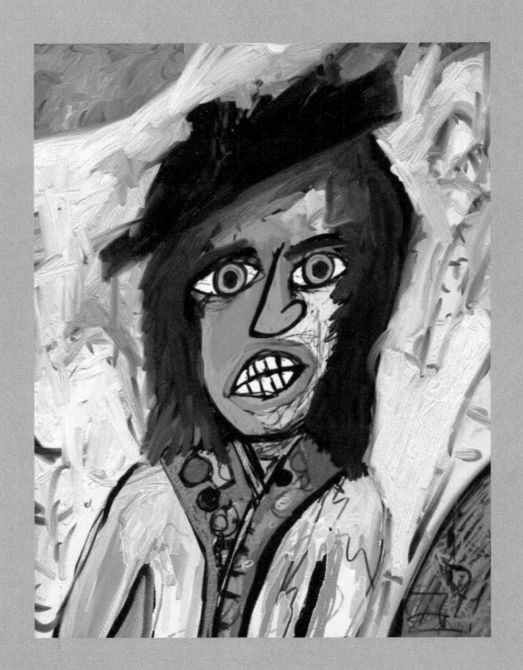

Did you ever slip on a roof pitched too steep and feel the slide begin

scrambling to stop nothin to grip knowin you won't stop and the ground

will come up too soon hurtin like hell when you land?

Can you sense the slide?

When a tractor-trailer truck jackknifes you feel it first in your ass even

before the windshield goes sideways as told in truck stops and as hap-

pened at a red light in New Orleans on a slick city street

I feel it in my ass

The slide toward the abyss of the end of empire

The laws of survival endure

The Light Inside Us

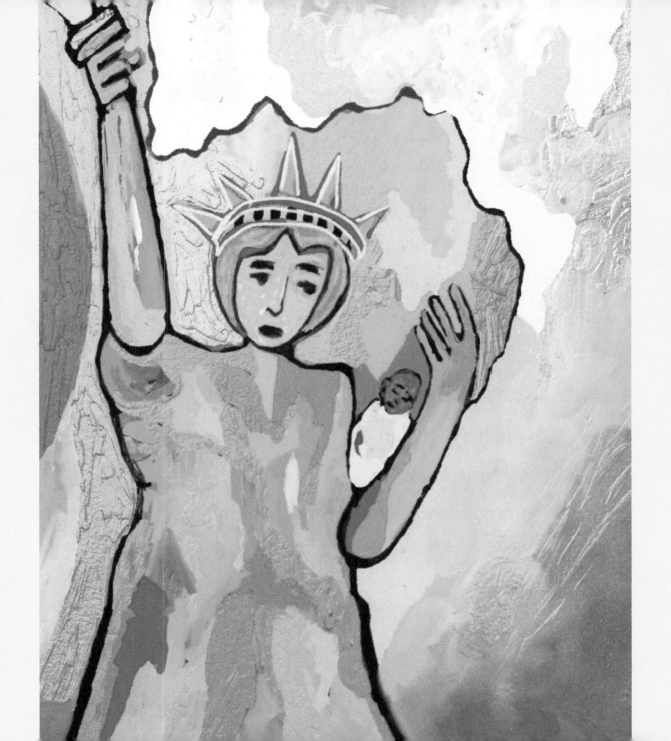

May the light inside us

So shine that others see and feel

The love freely given us

May we share that love above all else

With one another but especially to the Other

May we remember that when we lead with love

We offer the greatest gift ever given us

The connection we all seek, the love of one soul to another

May we work with holy strength

To see that love reflected in what we do together

To become a country and society that stands for the freedom for all, yes

(continued)

But also a society and country that honors compassion

May we stand feet planted in this land of liberty for all

In our common struggle for justice

So that there is room more than enough for fellow Americans not born here

May we know that being American is so much more than where you're born

That being American means we walk in the light of Lincoln and King

and Milk and Anthony

That there is no need for greed in a place so full for all

May we again reach even beyond our grasp to be the beacon we were

meant to be

At what cost to this empire?

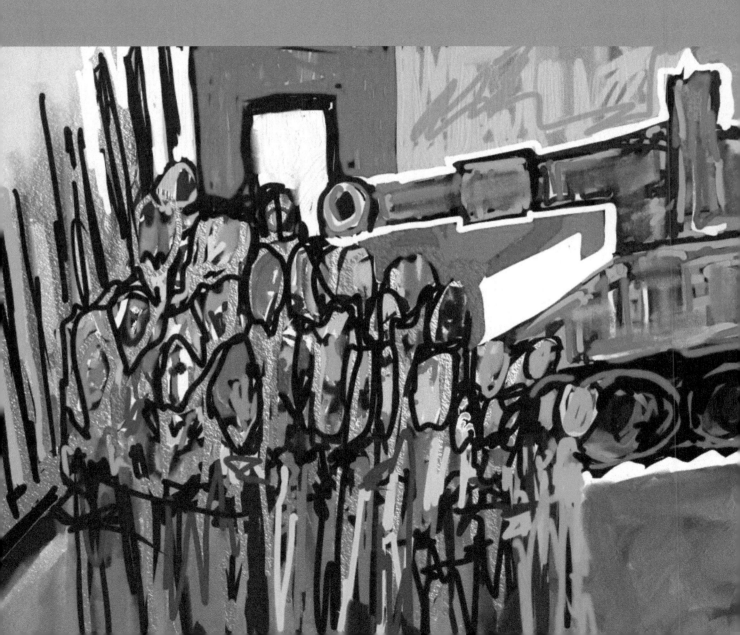

At what cost this empire with young Americans scattered across country after country

These young troops grow old and older hoping to hide their pain as they hobble around our streets

What do we call a country that once aspired to deep democracy

But decided on empire?

At what cost this empire?

As we kill kids without provocation

And ensure the deaths of millions

While leaders take their place humanity's most horrible

At what cost this empire?

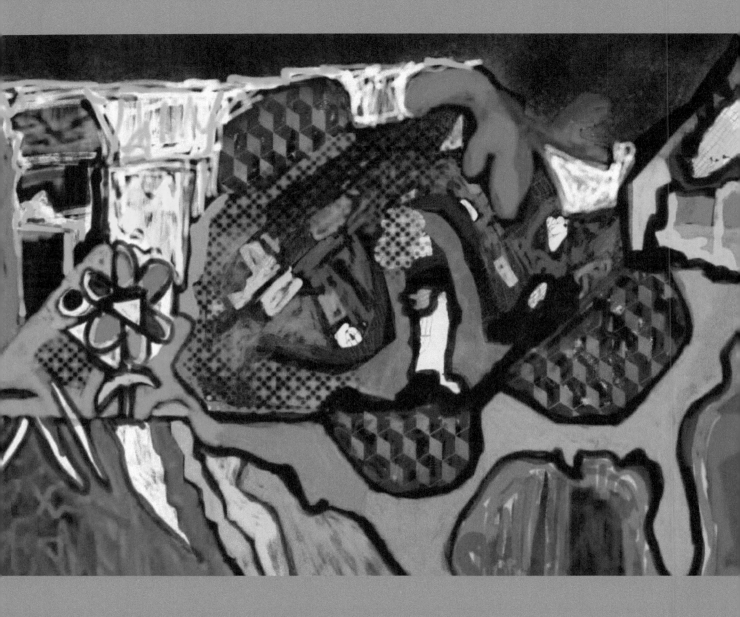

A once mighty country faced with reality of empire

Soldiers dying around the world, poverty and misery at home

Society's fabric ripping, kids dying, hate and anger seem to be winning

But a mighty resistance rising

Determined to end innocent kids dying

Declaring war on poverty in the land of plenty

Returning to a commitment to the common good

The people pushing to replace the greed with meeting need

Victory hard to see in this time of crisis

But a once mighty country's people determined to end the misery

The Resistence rising.

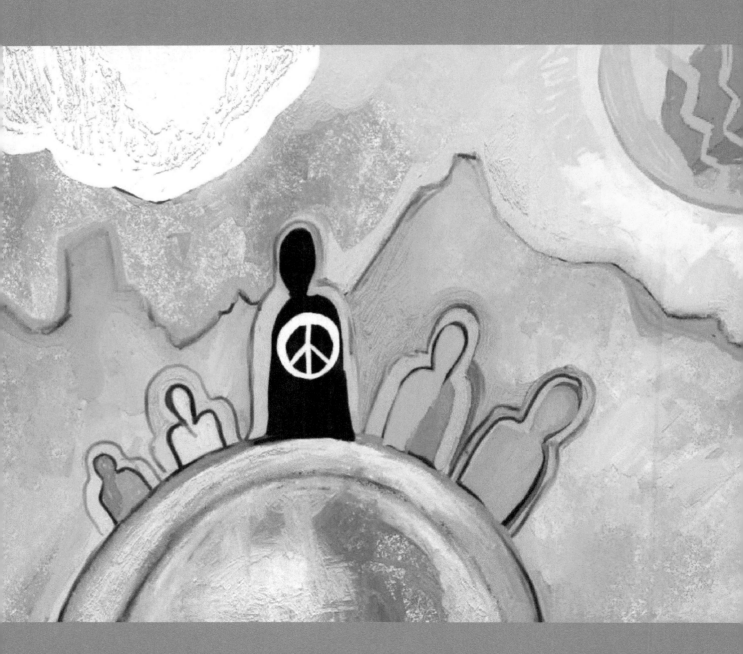

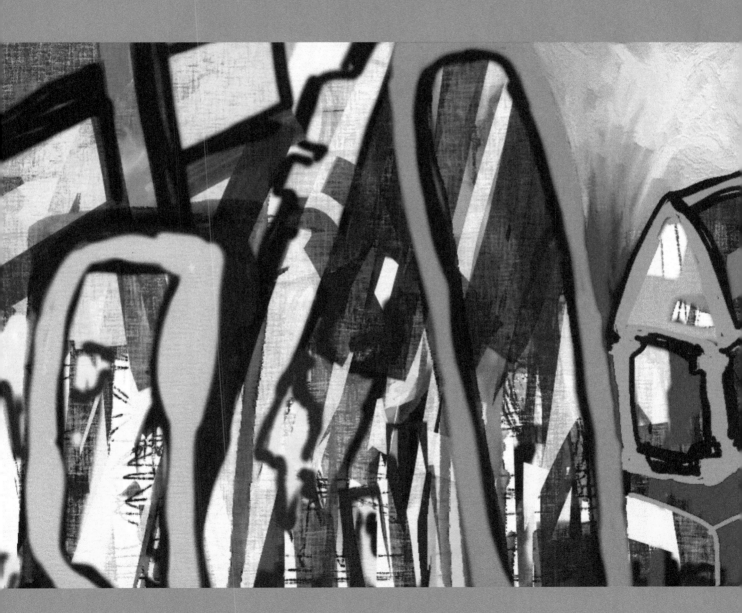

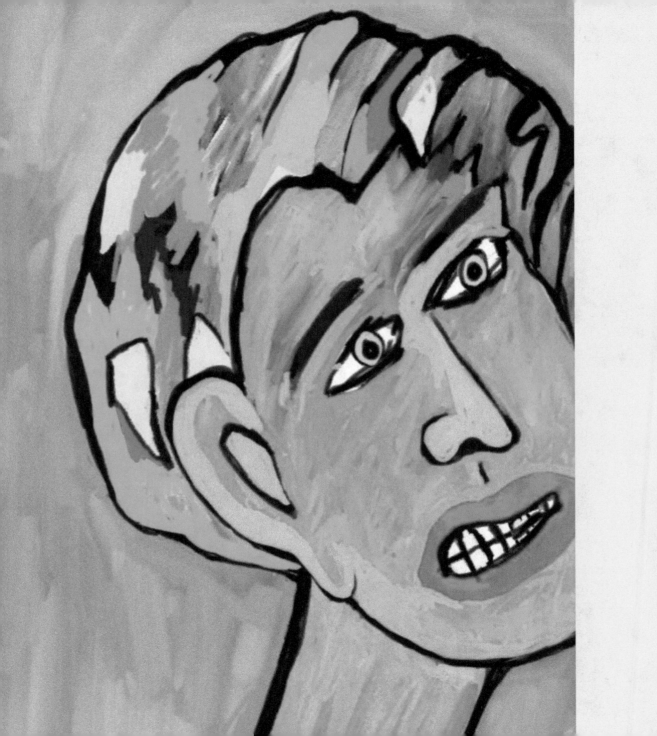

I can no longer hear your heart

It is the sound of your feet moving to me that I need

We can only free ourselves in the struggle to free the other

When he degrades you, he degrades my sister

When he despises you, he despises all I've ever loved

When my heart is heavy, it is the weight of your burden

My joy comes through you.

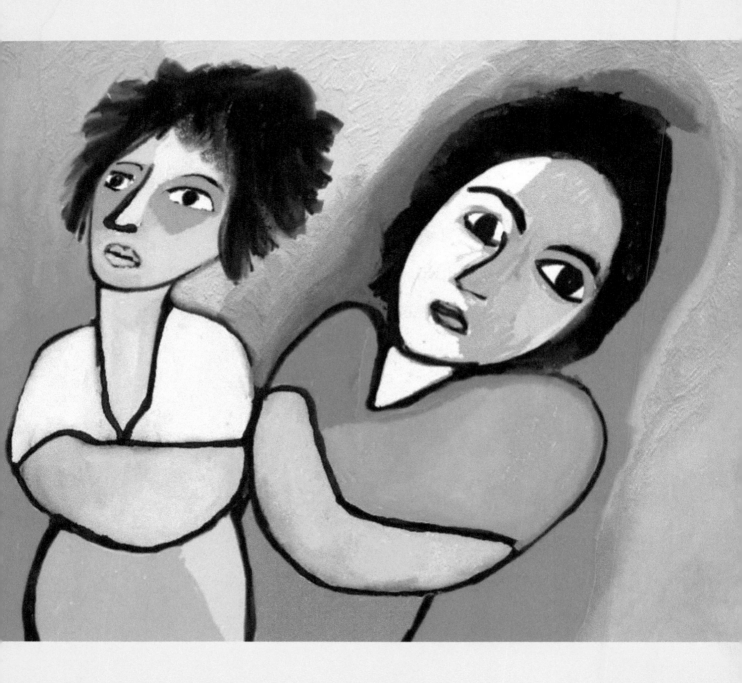

Wake the day without dread

Meet the morning magnificent

Worship the divine in one another

Sing songs of glory

Pray hard for the peace that passeth understanding

It is a time of trial, we are tested

The divine force in each calls us to our feet

We are neither weak nor too worn to do what must be done

Stand by me, may we each feel the others strength

Praise the power of love and compassion

Help me hold hard to the values of our humanity

Help me love unconditionally

May we water our warrior souls from the eternal spring of solidarity

She was once a princess

Now a warrior woman for justice

A goddess of our universe

Creator of beauty with her body in dance

She flows through her world with the grace of water dancing through rocks

Not easy to be far from her

She stays on my heart, in my mind, our souls wound and bound together freely

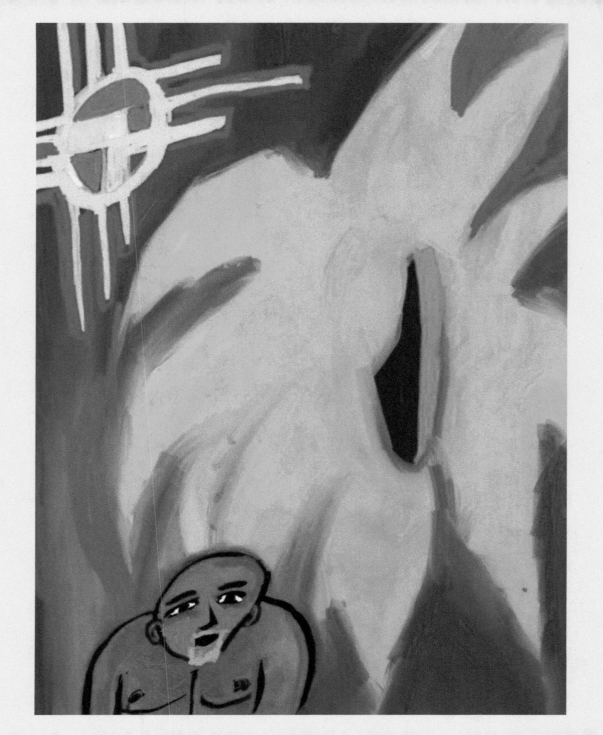

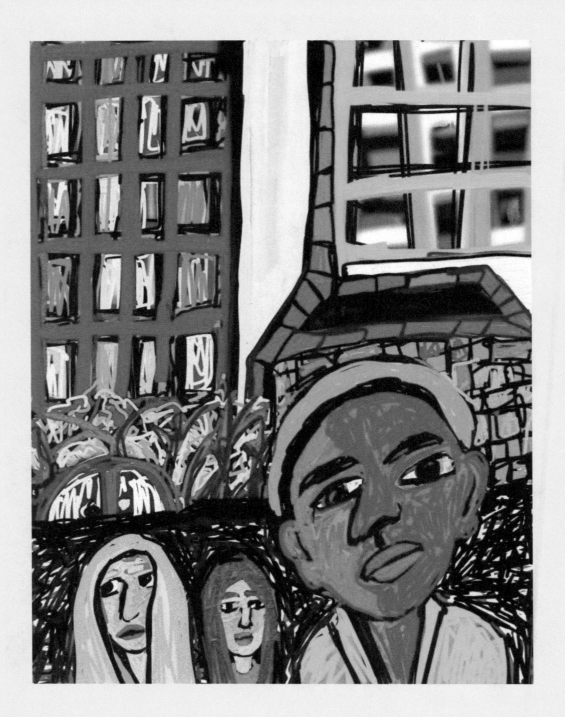

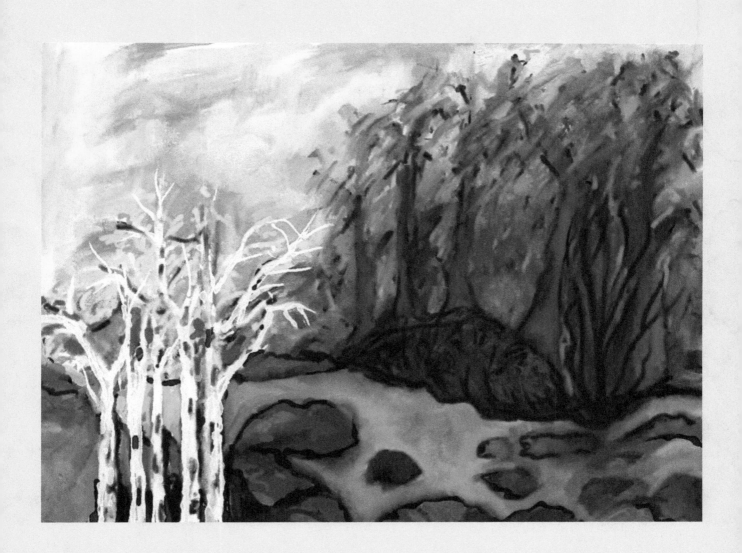

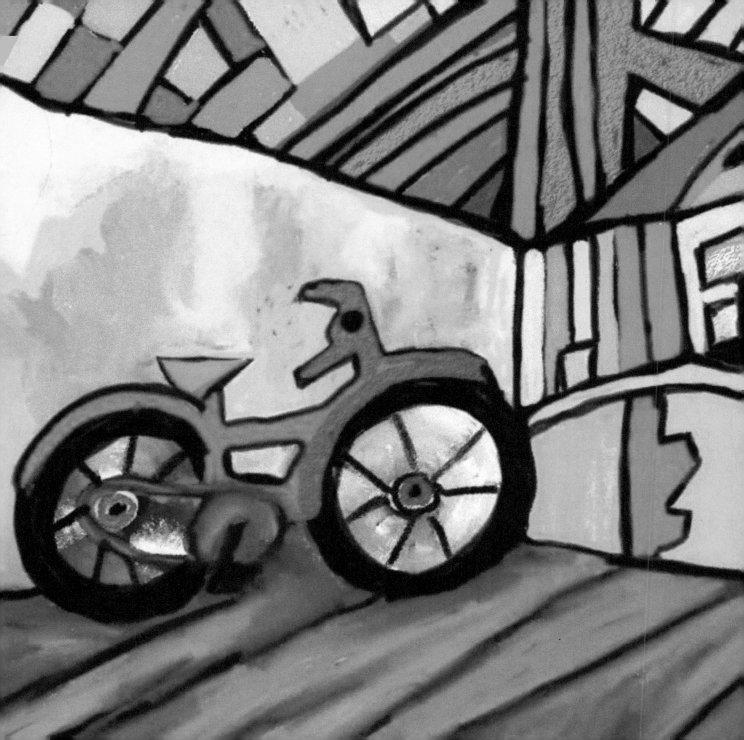

I
drove
those
roads
fight
to
fight

There's a dry rub rib place called the Redezvous

In Memphis off Union in an alley

Once when feeling independent

We drove from Senath, Missouri

To git ribs at the Rendezvous

Never meant to road trip thru this morning's memories

But I've been blessed to have had hundreds of meetings

In the South's best bastions of barbecue

Dozens of roadside rib shacks across South Georgia

Best barbecue in Birmingham after we buried Rev. Oranges mother

T Bones Sports grill in Chattanooga with Jerry Lee Lewis fightin for

Harold Ford

Whitts in Nashville for Ford still

An alley place called Rendezvous in Memphis

I drove those roads from fight to fight.

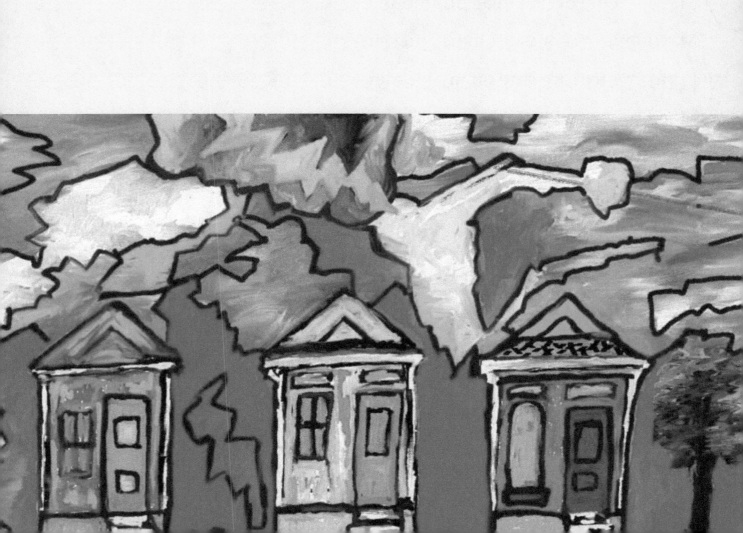

Today may I live in your light

May I remain grateful all this day

May I see the divine in all around me

May I love others as brothers and sisters

I pray my feet are sure on my journey

May I be moved by righteous desire for freedom and justice

May my heart bear love to others, my soul a well of compassion

May I know joy today on this way I've chosen

I pray that on this day others feel the love so freely given to me

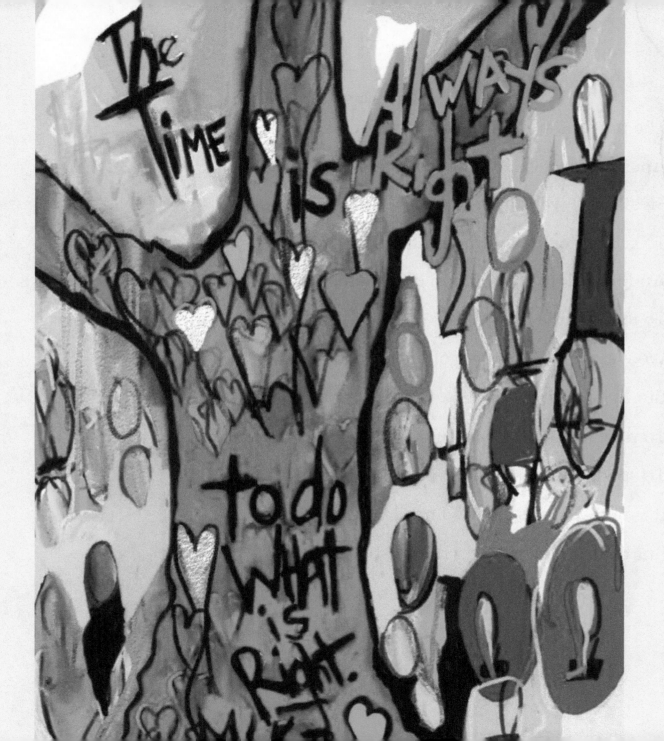

The power that pulls us to one another

Ancient, mystical, divine

Swells and wells in our deepest desires

To celebrate our common humanity

And to look for the light in one another

To look for the love in the other

We were not born to negotiate our way alone

But to join our strength

To pool the poor power of one into our commonality

To spend our spirits in search of the souls of one another

It is not weakness to say I need you

But the ultimate sources of our strength

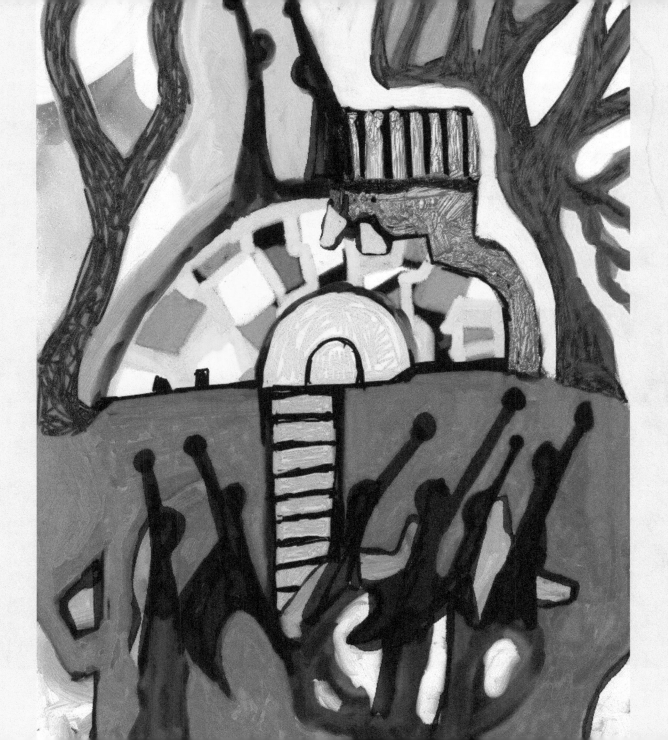

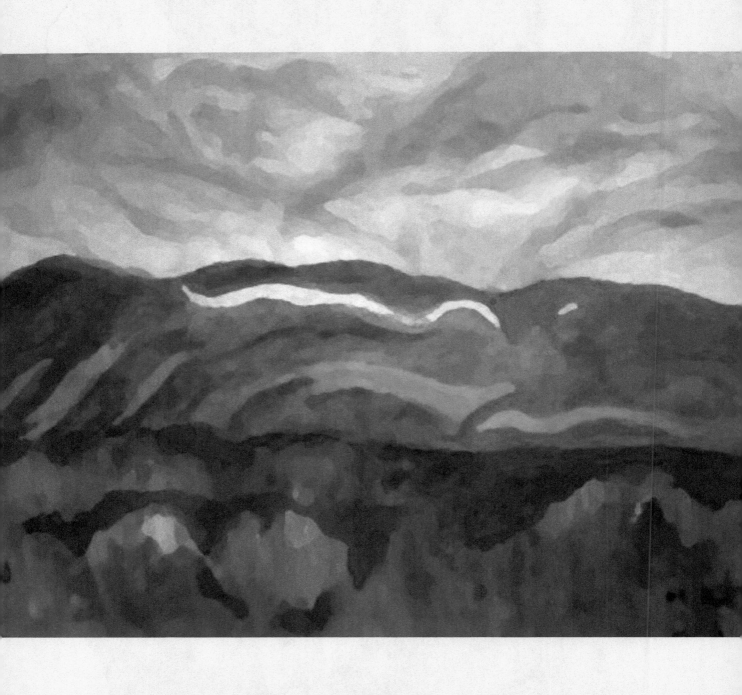

Morning light breaks the night

Beginning again the new day

While the day is fresh we take first steps

In a world made anew after every night

Today we will make our way

On this step of the long trail started lifetimes ago

In the broken light breaking, asking

How this one counts, what will this one be

So I reach back to the trail markers of my life

Love, compassion, justice

Stay with me this day, direct my step.

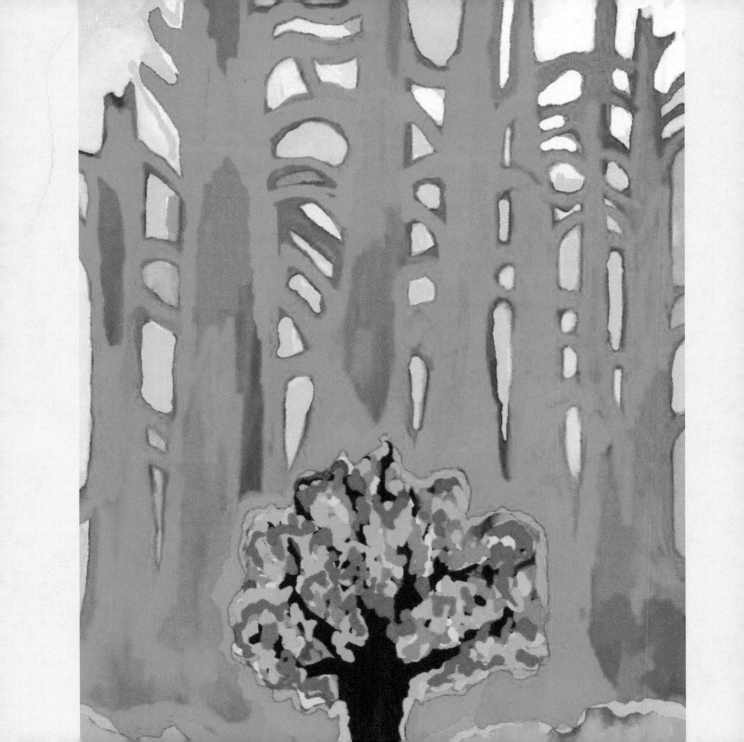

FOR MY DAUGHTER

Syd, you always held us all in your tiny hand
Now growing into a woman wise to this world
Already making your mark from the start
Artistic, academic, creative, energetic
Striding across a stage to capture a crowd
Painting your world as it is and as you see it
My love for you is overflowing, everlasting, absolute

FOR MY SON

Sam has become a young man Musical,
creative, athletic, artistic
This Christmas you bless me with your free spirit I love to
listen to you on the skins
And admire you trying new tricks on the board
My love for you is overflowing,everlasting,absolute

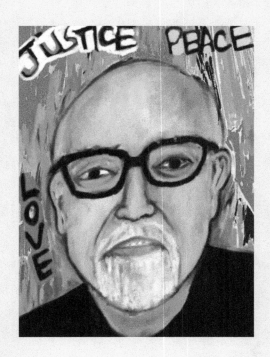

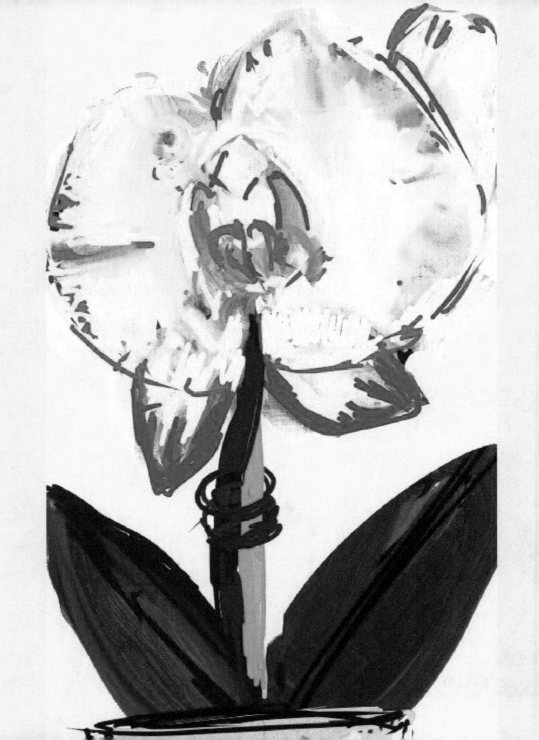

In the early gray of false dawn I open myself to a new day

My feathered fellows mark their turf in a harmony of cacophony

I begin this day with the hope for new blessings that may

Teach us that we share not just a planet but a universe of pain but also of joy

My I find and sow that joy with others on their own journey

I will try all day to find a way to help lift another's spirit on their way

Once again this day I know that unity in love will always be

My greatest gift to all I see.

(For Max and Val, Valerie is Awesome)

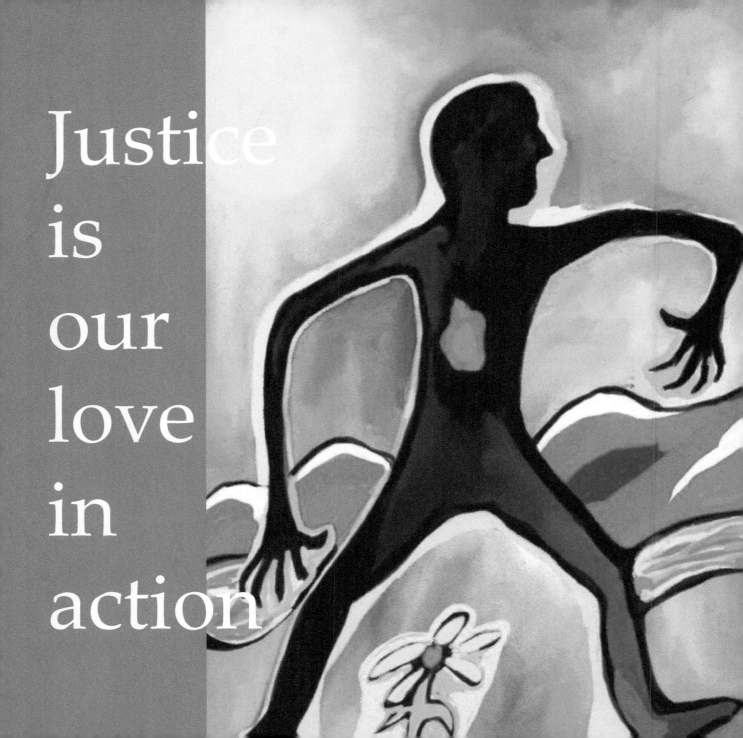

Justice
is
our
love
in
action

Hard tho it is to hold hard to our hearts

It is always in the end, love that matters most

Tho the enemies of all that is good, hate with a heat not seen since lynchings

The trail we tread through dark corners must be the trail to compassion

We listen for the still, small voice in each of us and look

for the light of the divine

Looking to one another with eyes of love we follow to fulfill the ancient

admonition to love one another

Justice is love in action, making real the solidarity of our souls

Righteous justice isthe comingend of the efforts of our hearts.

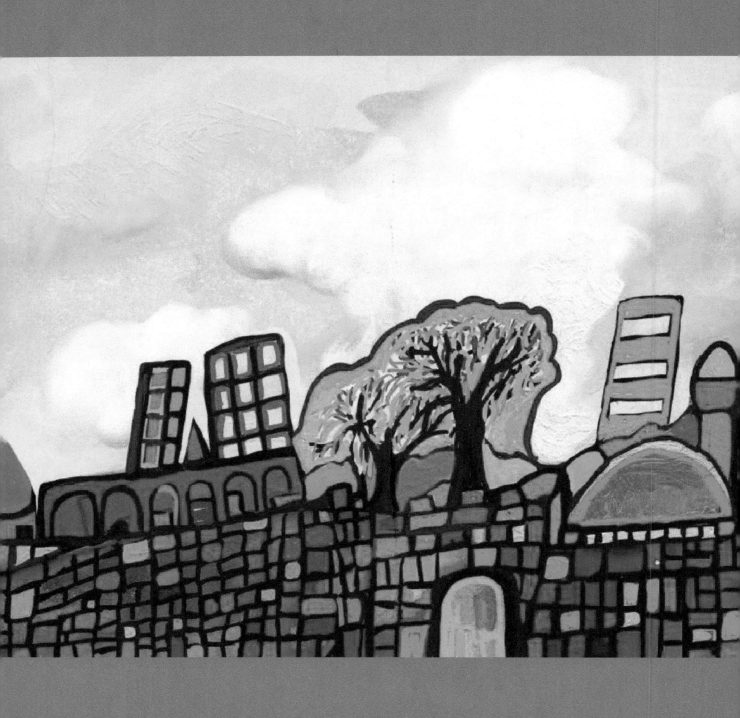

An almost perfect summer Saturday morning in Martinsburg, West Virginia

Sun on shoulders soft and warm like a poultice for a pulled muscle

Breeze easy, sweet to soften the heat

Sky changing the hues of its blues as my eyes move to the horizon with traces of clouds making way for new clarity

Life still has much in store for me, but I wouldn't mind going home on a day like this.

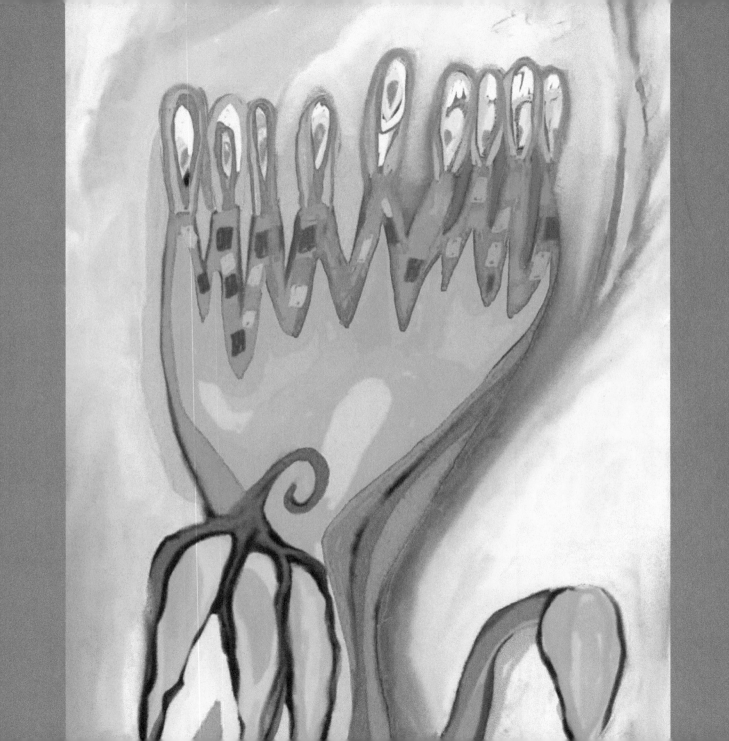

4th of July

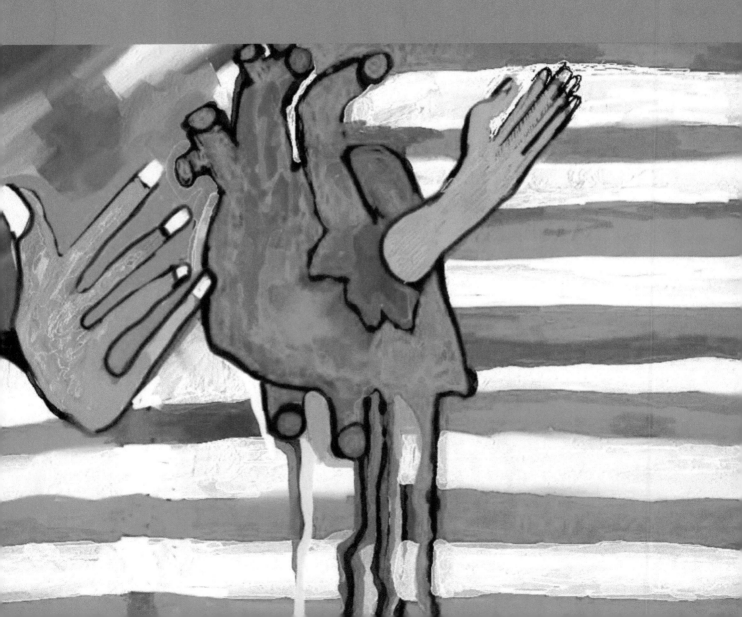

4th of July

Time to celebrate independence

Freedom from tyranny

The long struggle to free all Americans

And to extend America's promise

To all her people, right?

Without regard to race, creed, color,

Gender, sexual orientation, language,

Place of birth, choice of love

No, not this 4th, not now

But the 4th is not just about Independence

It is when Vicksburg, MS fell to Union forces

Opening up the Mississippi River to the

Union from Minnesota to New Orleans

(continued)

The 4th of July, the very same day is when

Union forces drove Lee's Army of the

Confederacy from the battlefield of blood

At Gettysburg.

That great struggle to free

African-Americans turned the irreversible

Corner on the 4th of July, 1863 and the

Union began to win, ushering in a longer

Struggle for freedom and justice and

Equal rights for all, finally realized in

The Civil Rights Act of 1964 and the

Voting Rights Act of 1965.

(continued)

And now it no longer counts?

800,000 lives in the Civil War

Numberless lynchings – do you know what

A lynching is? It ain't just a hanging

It is hours of sadistic torture with whippings

And castration and burnings and sadism

Of every sort.

And now this Supreme Court says that's okay

The states have the right to deny what so

Many died for and suffered for

Is the Supreme Court of these United States

That ignorant or that redneck, peckerwood

Mean. I've seen 'em mean and they enjoy it

Like the peckerwood beat Ann Richards

For Governor – if rape is inevitable just lay

Back and enjoy it.

(continued)

Tears will run down my cheeks this

4th of July for what our own Supreme Racist

Court has cost These United States

And the folks who meant to settle these

Questions once and for all on the 4th of July

At Vicksburg and Gettysburg

And at Selma and Birmingham and Albany

And Montgomery and Greensboro and

South Carolina State in Orangeburg

And in the sears and scars in the hearts

And souls of so many Americans

Who struggled to make America real.

Really, this 4th of July you five men

Decide none of that mattered, not the

Midnight screams and babies without

(continued)

Daddies and four little girls in church in

Bombingham. None of it mattered.

Not the integrity of a nation?

Mr. 5 Supreme Court justices may you

Hear the screams at Gettysburg and see the

Hunger at Vicksburg, may you see

John Lewis and his clubbing and

Viola Liuzzo and her shooting on Route 80

Mr. 5 Supreme Court justices may you

Hear the screams of Chaney, Goodman and

Schwerner as they were tortured to death

Outside Philadelphia, Miss. May you hear

The wails of the parents of 4 little girls in

Bombingham, Al.

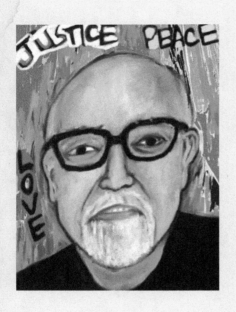

Stewart Acuff was National Organizing Director and Special Assistant to the President of the AFL-CIO. His career included community organizing with ACORN and two decades of successful union organizing in the Deep South of Georgia and East Texas. He is now retired and writing. His poetry often appears in a variety of publications. He continues organizing work with local activism and leadership development, radio and tv commentary, public speaking and training.

Mitch Klein is an artist. He's basically been doing art in one form or another his whole life...mostly to deal with boredom, anxiety, issues, feelings, etc.

A lot of the art thatMitch does is in a digital format these days. He can produce art faster and put it together in different presentations. Mitch also has done lots of paintings including work in oil, acrylic, and water color. He's done thousands of sketches and doodles over the over the years...and even a few fiber arts and sculpture type things.

Mitch lives in New Orleans Louisiana with his wife Valerie Coffin and son Max Antonio Coffin Klein. Mitch has been involved in a variety of businesses and organizations. He believes in the struggle for fairness, justice, freedom, and compassion in the world and tries to live that way. Mitch's art often reflects these life experiences.

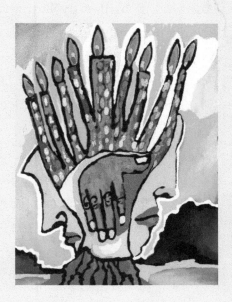

TITLES FROM HARD BALL PRESS

The Man Who Fell From the Sky - Bill Fletcher, Jr

I Still Can't Fly - Confessions of a Lifelong Troublemaker - Kevin John Carroll

A Great Vision – A Militant Family's Journey Through the Twentieth Century – by Richard March

Caring – 1199 Nursing Home Workers Tell Their Story

Fight For Your Long Day – Classroom Edition, by Alex Kudera

Love Dies, a thriller, by Timothy Sheard

Murder of a Post Office Manager, A Legal Thriller, by Paul Felton

New York Hustle – Pool Rooms, School Rooms and Street Corners, a memoir, Stan Maron

Passion's Pride – Return to the Dawning, Cathie Wright- Lewis

The Secrets of the Snow, a book of p0etry, Hiva Panahi

Sixteen Tons, a Novel, by Kevin Corley

Throw Out the Water, the sequel to Sixteen Tons, by Kevin Corley

We Are One – Stories of Work, Life & Love, Elizabeth Gottieb (editor)

What Did You Learn at Work Today? The Forbidden Lessons of Labor Education, by Helena Worthen

With Our Loving Hands – 1199 Nursing Home Workers Tell Their Story

Winning Richmond – How a Progressive Alliance Won City Hall, by Gayle McLaughlin

Woman Missing, A Mill Town Mystery, by Linda Nordquist

THE LENNY MOSS MYSTERIES by Timothy Sheard

This Won't Hurt A Bit
Some Cuts Never Heal
A Race Against Death
No Place To Be Sick
Slim To None
A Bitter Pill
Someone Has To Die

CHILDREN'S BOOKS

The Cabbage That Came Back, Stephen Pearl (author), Rafael Pearl (Illustrator), Sara Pearl (translator)

Good Guy Jake, Mark Torres (author), Yana Podrieez (Illustrator), Madelin Arroyo (translator)

Hats Off For Gabbie, Marivir Montebon (author), Yana Podriez (illustrator), Madelin Arroyo (translator)

Jimmy's Carwash Adventure, Victor Narro (author & translator), Yana Podriez (illustrator)

Joelito's Big Decision, Ann Berlak (author), Daniel Camacho (Illustrator), José Antonio Galloso (Translator)

Manny & The Mango Tree, Ali R. Bustamante (author), Monica Lunot-Kuker (illustrator), Mauricio Niebla (translator)

Margarito's Forest, Andy Carter (author), Allison Havens (illustrator), Omar Mejia (Translator)

Polar Bear Pete's Ice is Melting! – Timothy Sheard (author), Madelin Arroyo (translator), A FALL 2018 RELEASE

Trailer Park – Jennifer Dillard (author), Madelin Arroyo (translator), Rafael Pearl (illustrator)